First Edition

Written by: Mr. Amari Soul

Library of Congress Cataloging-in-Publication Data has been applied for.

Be You!

Imperfect yet Perfectly YOU!

20 plus beautiful coloring pages of positive
and fun illustrations designed to inspire young girls to
accept and love themselves
for who they are.
This book is an entertaining way to build their
self-confidence, raise their self-esteem, and instill in them
powerful traits that they can carry with them
their entire life.
I have also included a page after each
picture that will allow young girls to write down 3 things
that make them feel they are exactly what the picture
says they are.
Here is where parents will also have the opportunity to sit
down with them and discuss the importance of believing
that they are Beautiful... They are Strong
and they will always be WORTH IT!

I am a young girl now, but one day I'll grow up to be a beautiful, Strong, Woman!

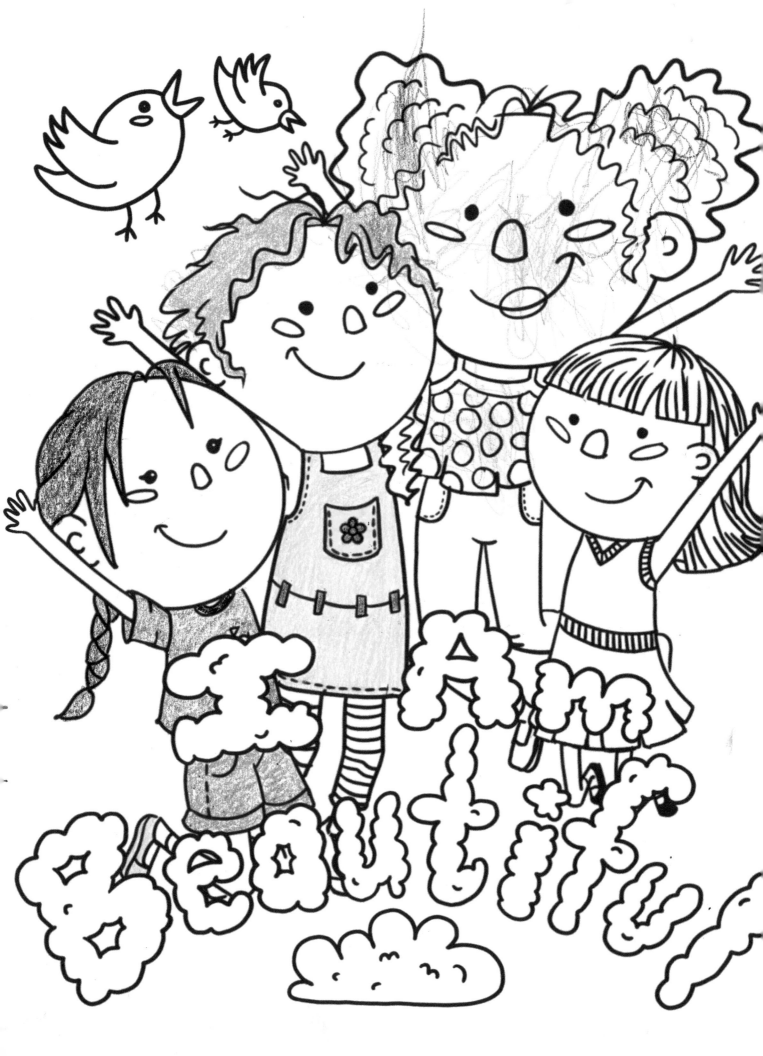

I know I am beautiful because...

1. When I spin around!

2. I am very kind!

3. my hair!

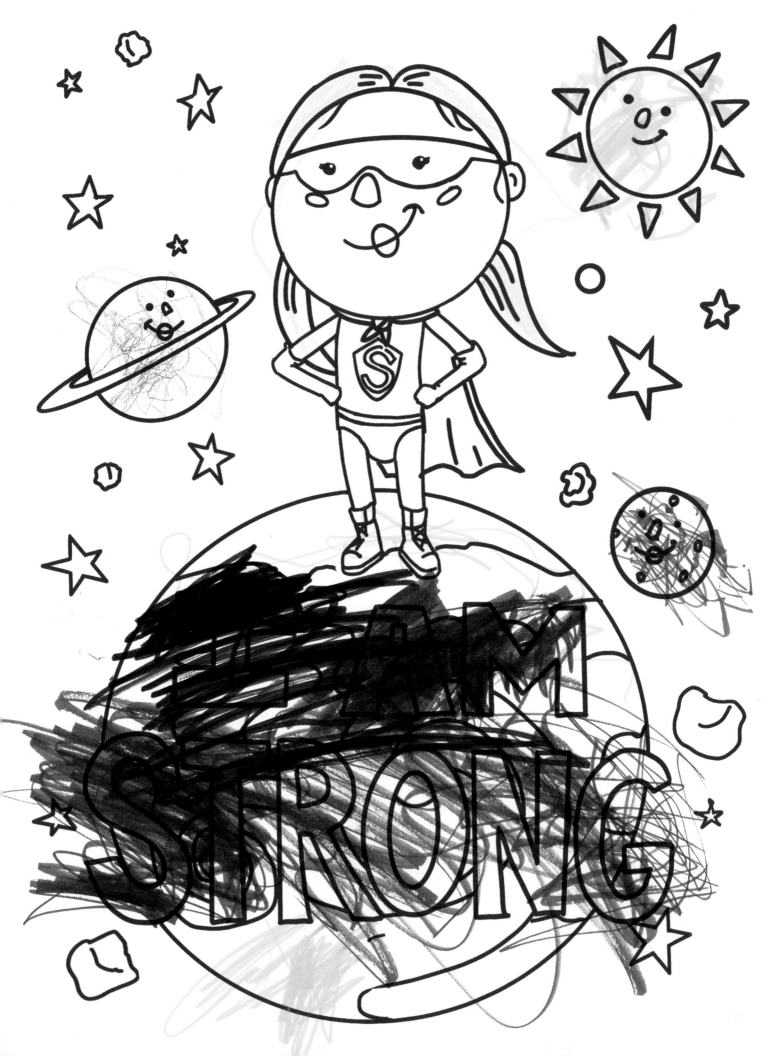

I know I am strong because...

1. Because I'm brave
 .

2. Because play astro naots
 .

3. I go w/ Bri and
 Bri is so much fun .

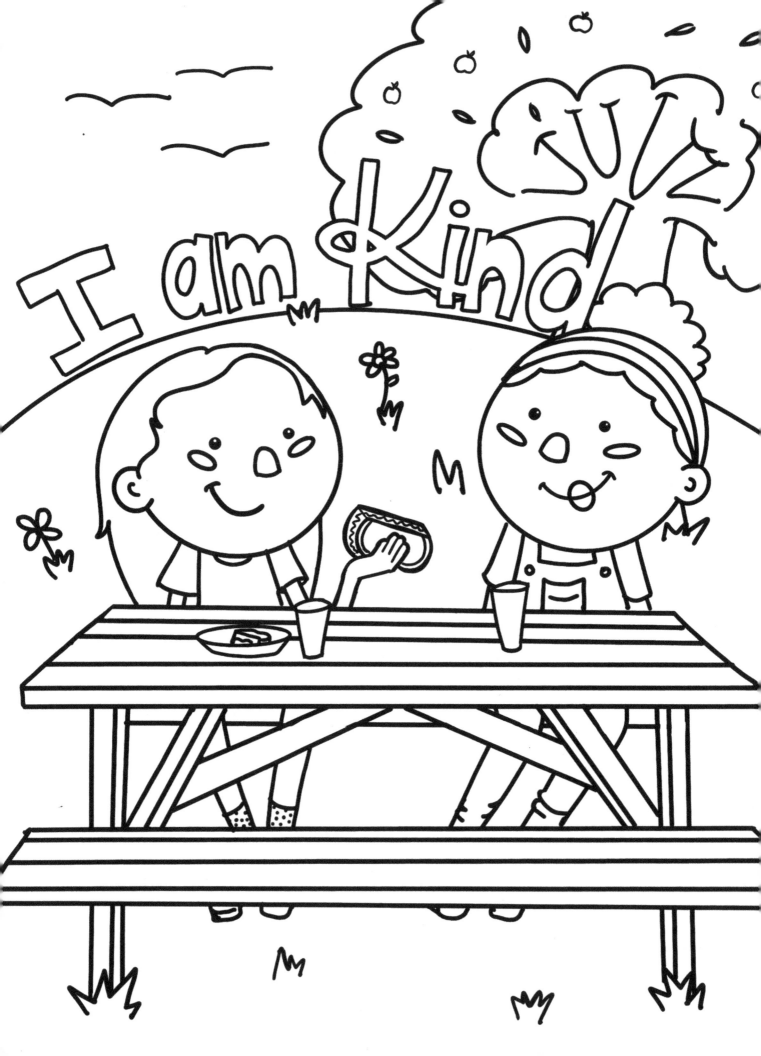

I know I am kind because...

1._____

_____.

2._____

_____.

3._____

_____.

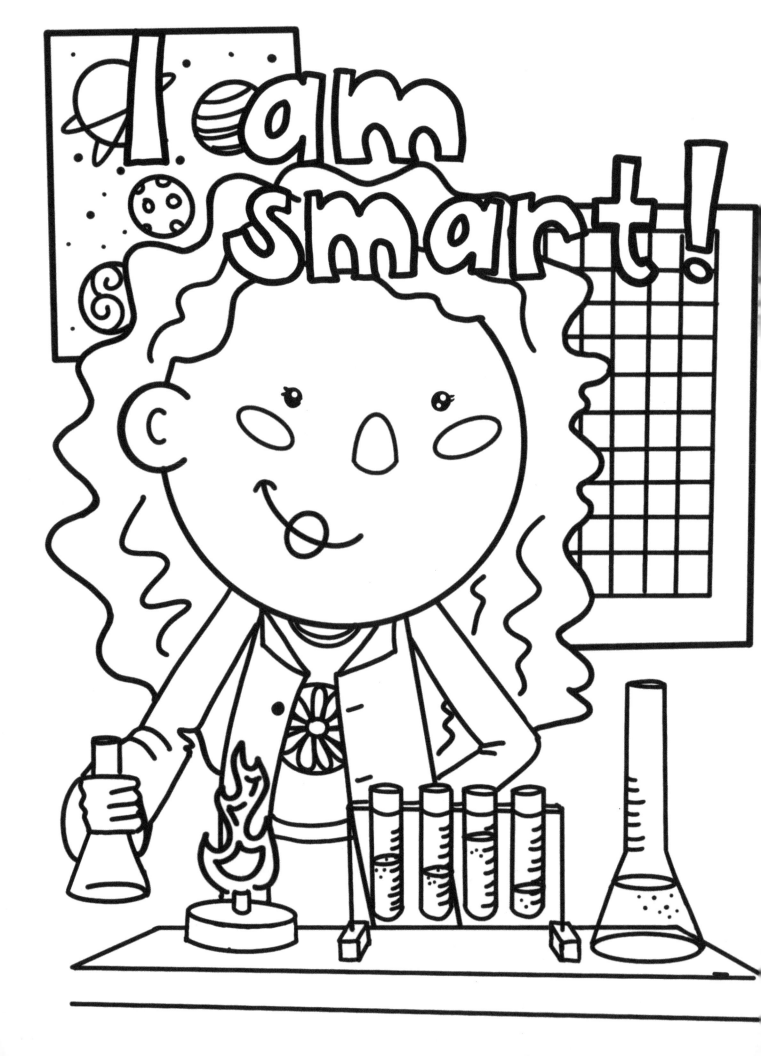

I know I am smart because...

1._____

_____.

2._____

_____.

3._____

_____.

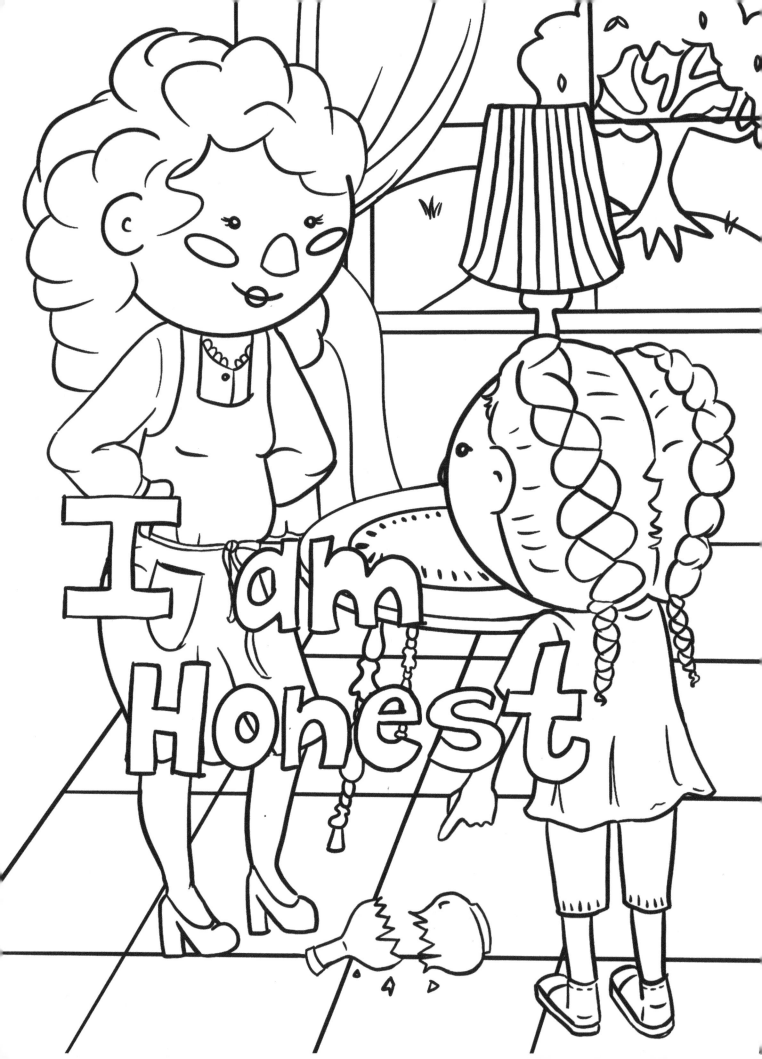

I know I am honest because...

1._____

_____.

2._____

_____.

3._____

_____.

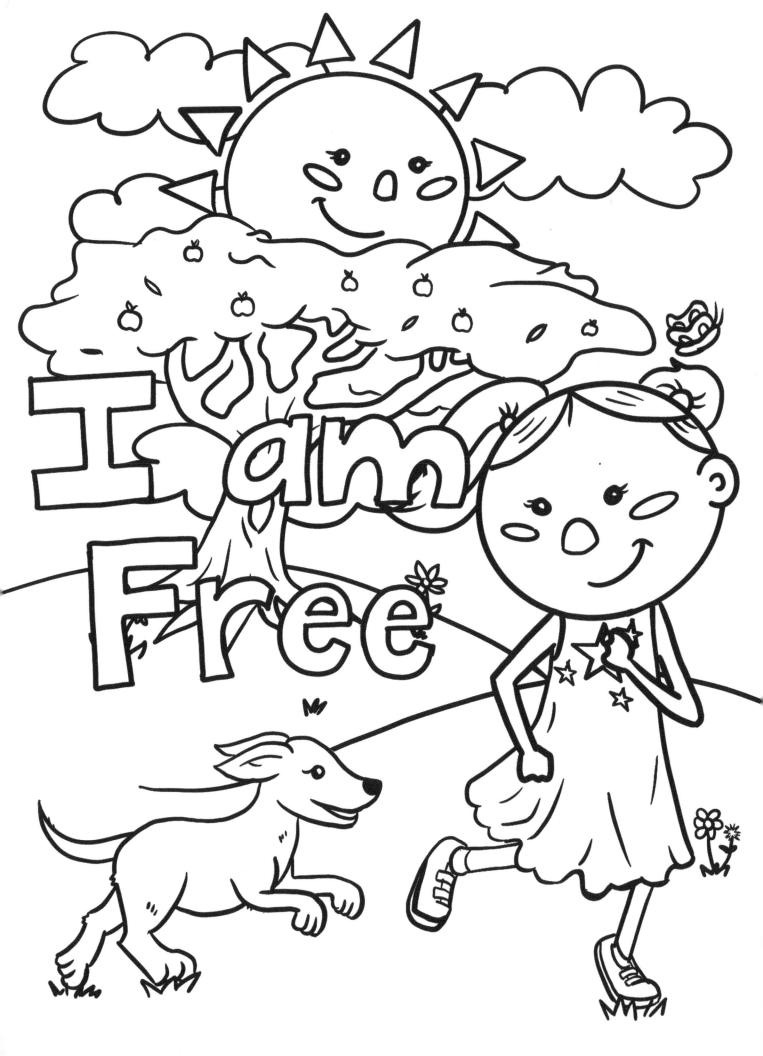

I know I am
free because...

1._____

_____ .

2._____

_____ .

3._____

_____ .

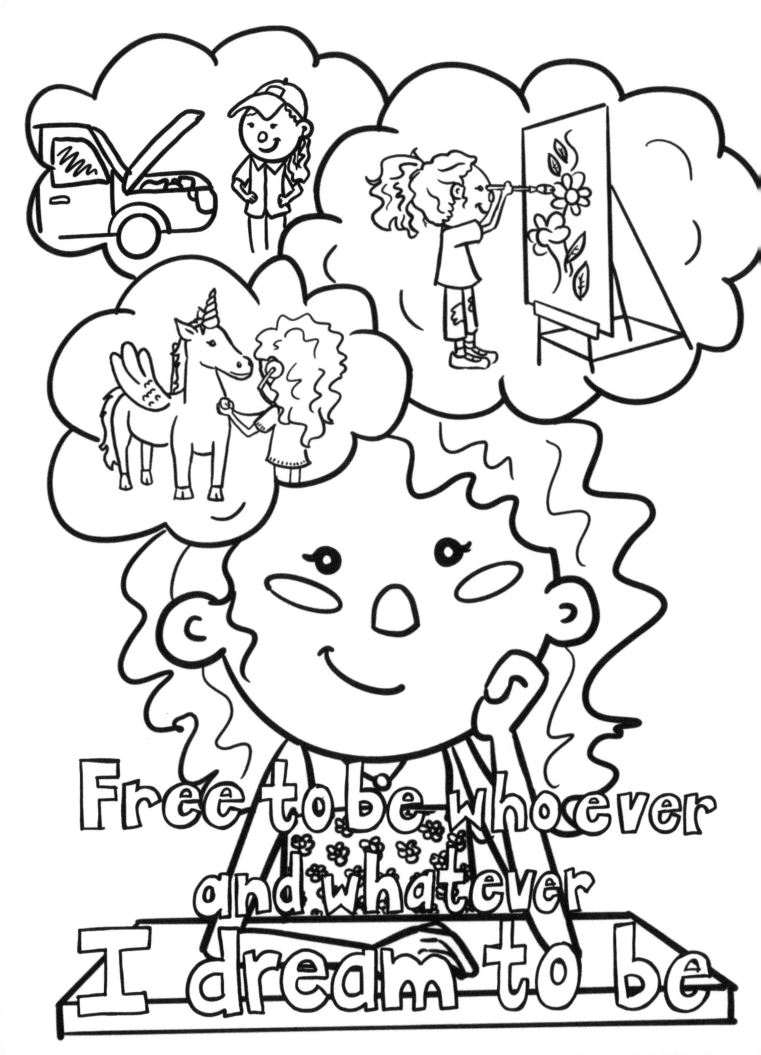

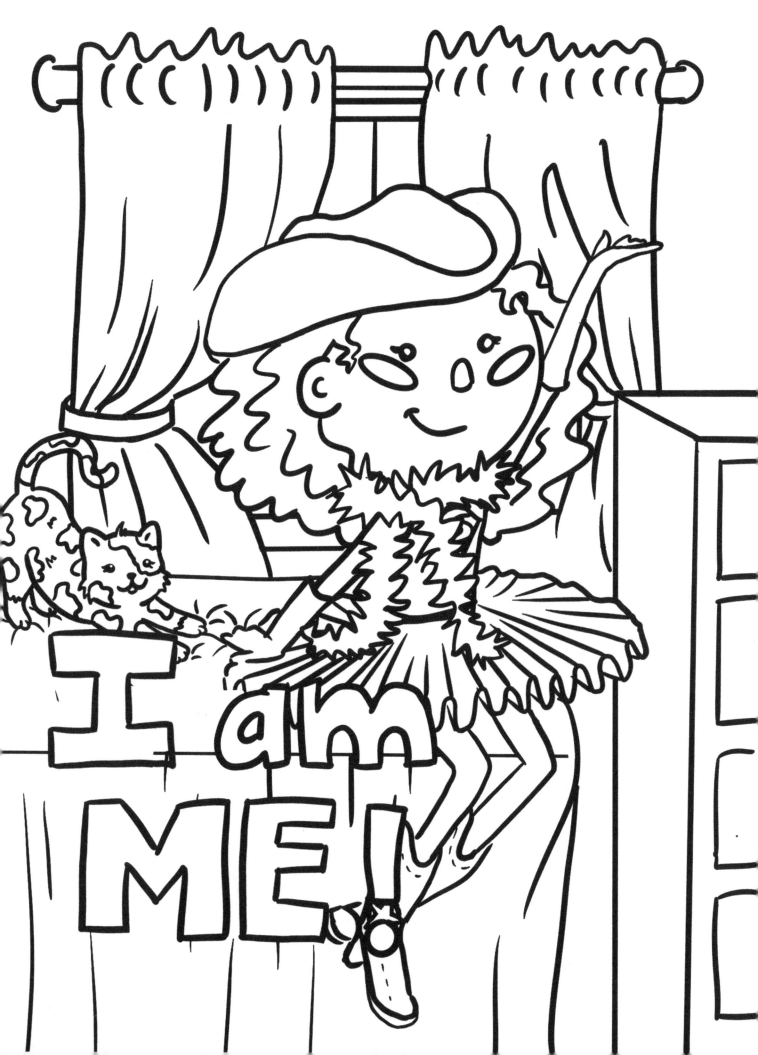

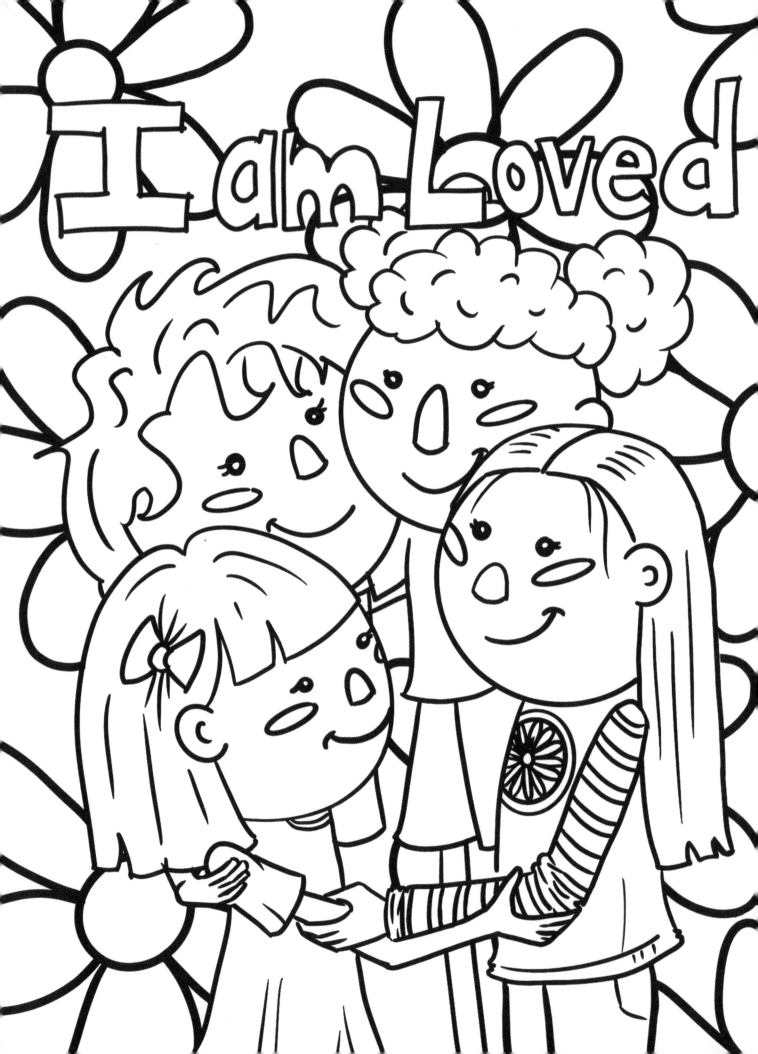

I know I am loved because...

1._____

_____.

2._____

_____.

3._____

_____.

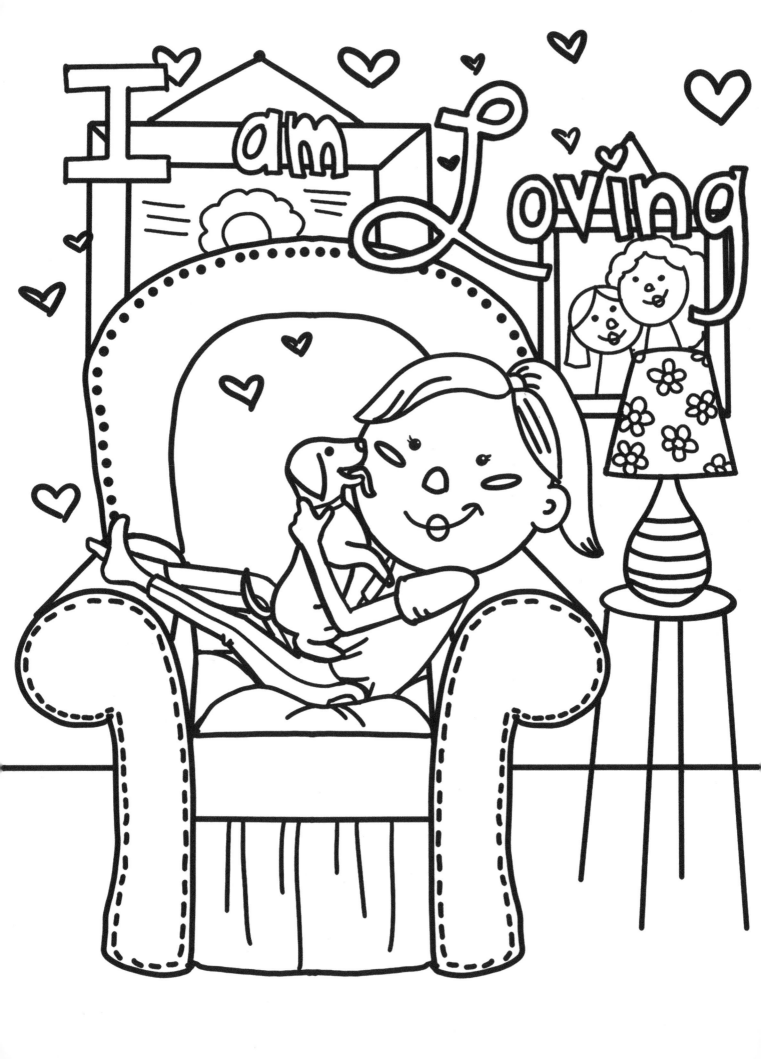

I know I am loving because...

1._____

_____.

2._____

_____.

3._____

_____.

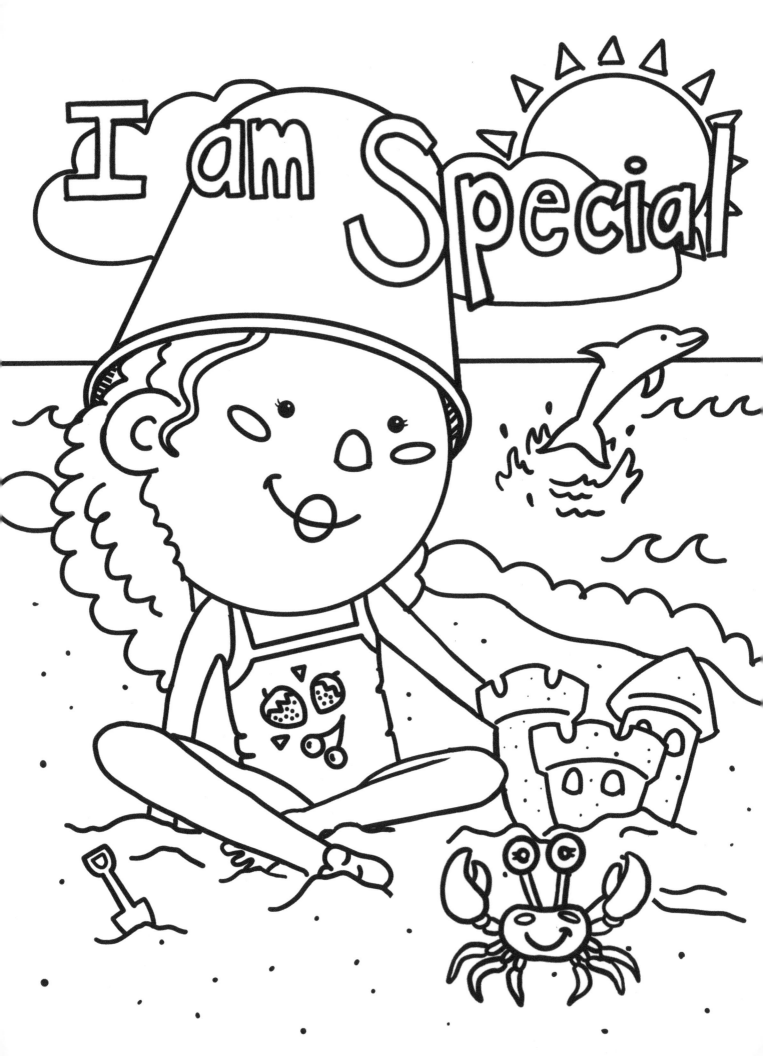

I know I am special because...

1._____
_____.

2._____
_____.

3._____
_____.

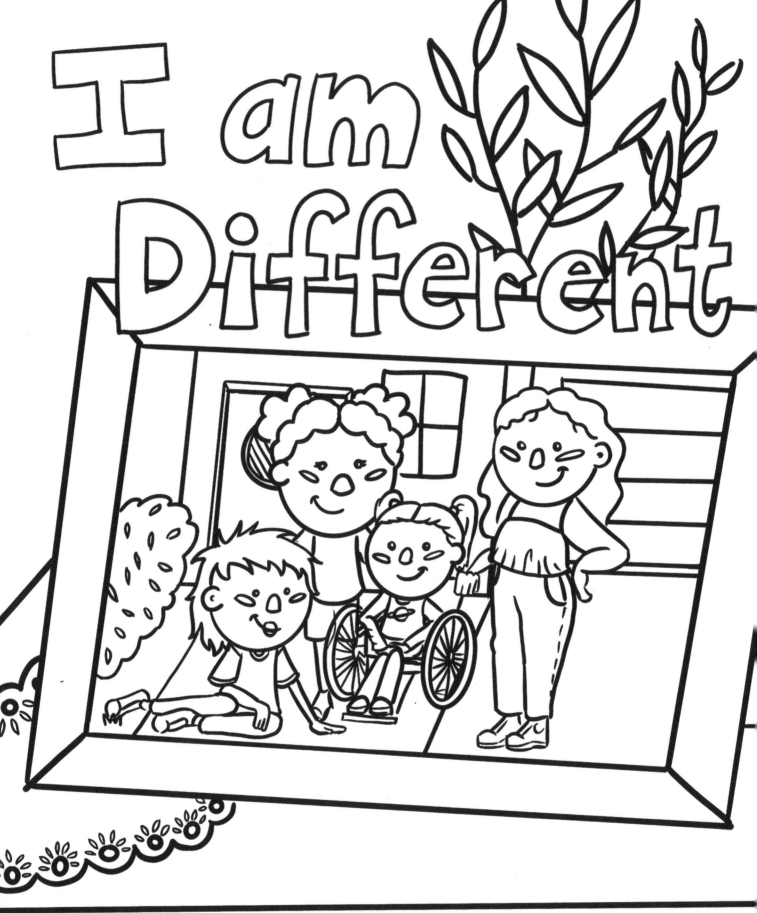

I know I am different because...

1._____

_____.

2._____

_____.

3._____

_____.

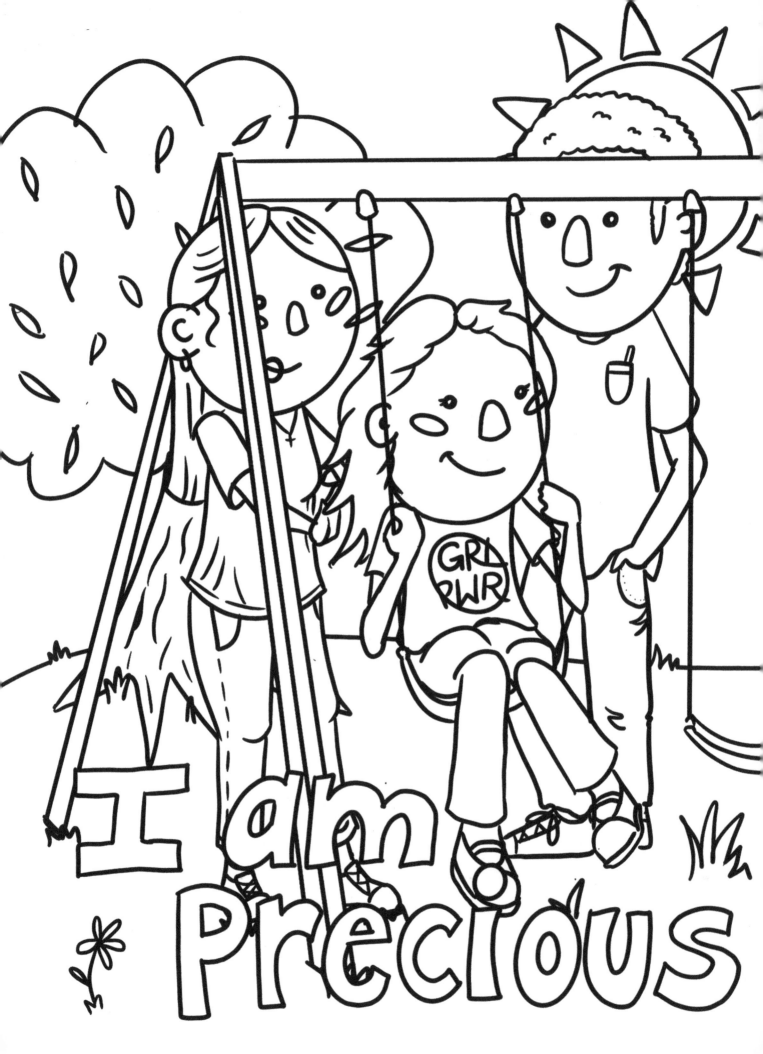

I know I am precious because...

1._____

_____.

2._____

_____.

3._____

_____.

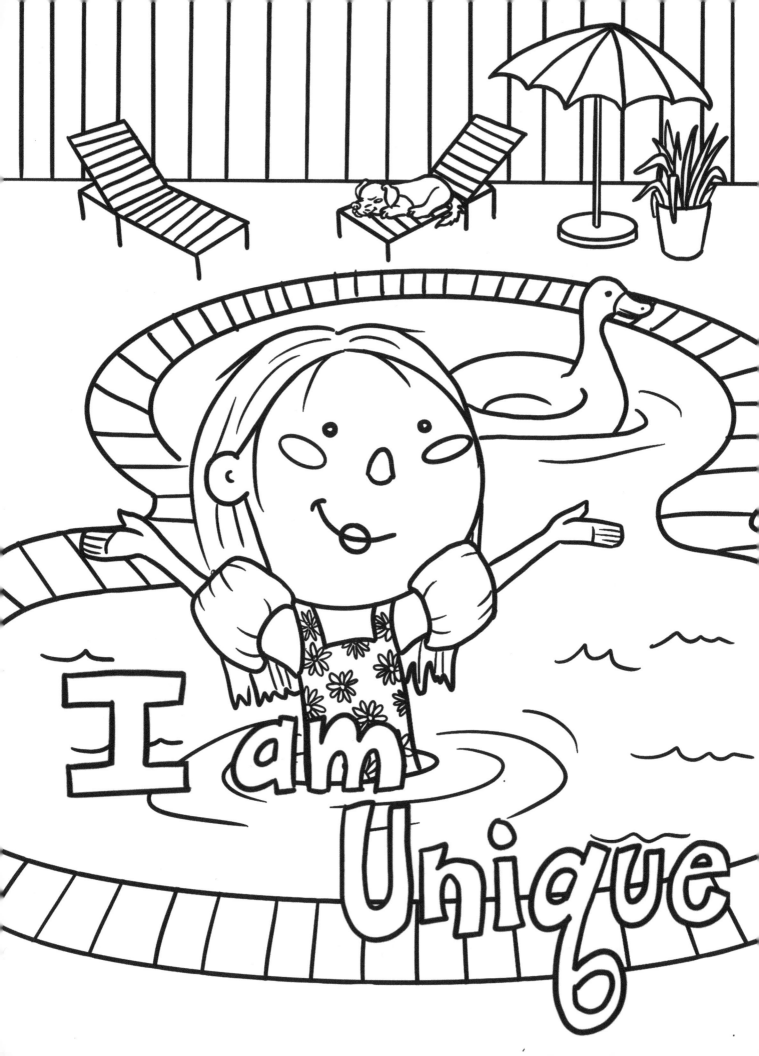

I know I am unique because...

1._____

_____.

2._____

_____.

3._____

_____.

I know I am helpful because...

1._____

_____.

2._____

_____.

3._____

_____.

I know I am funny because...

1._____

_____.

2._____

_____.

3._____

_____.

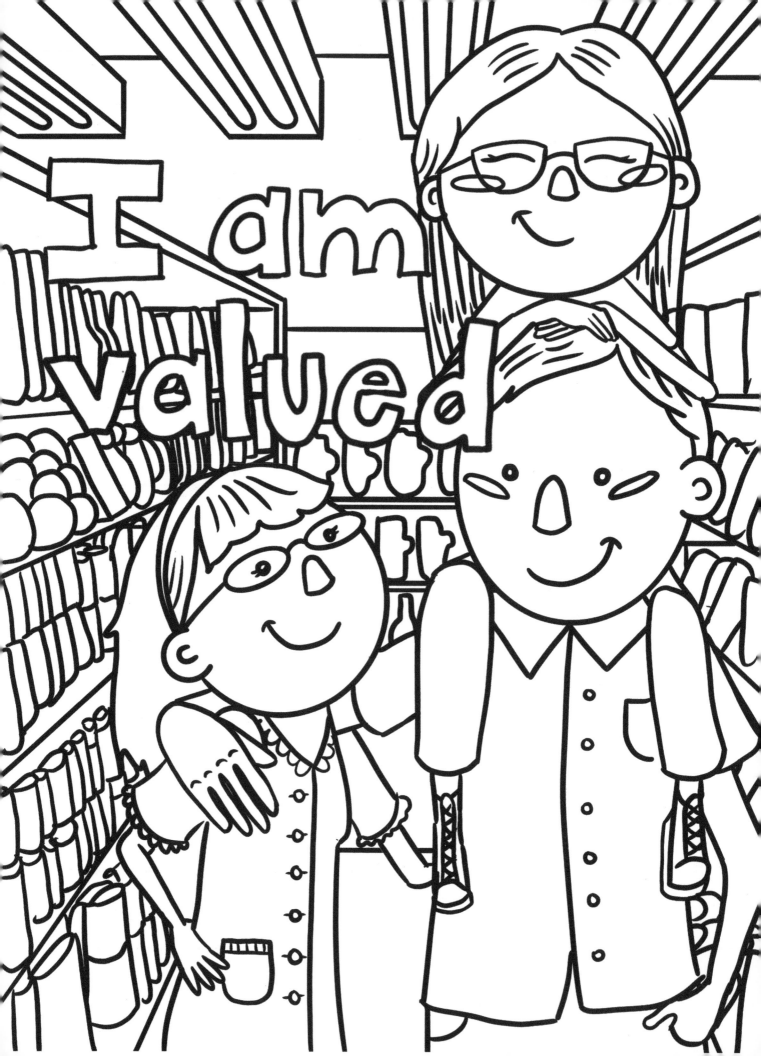

I know I am valued because...

1._____

_____.

2._____

_____.

3._____

_____.

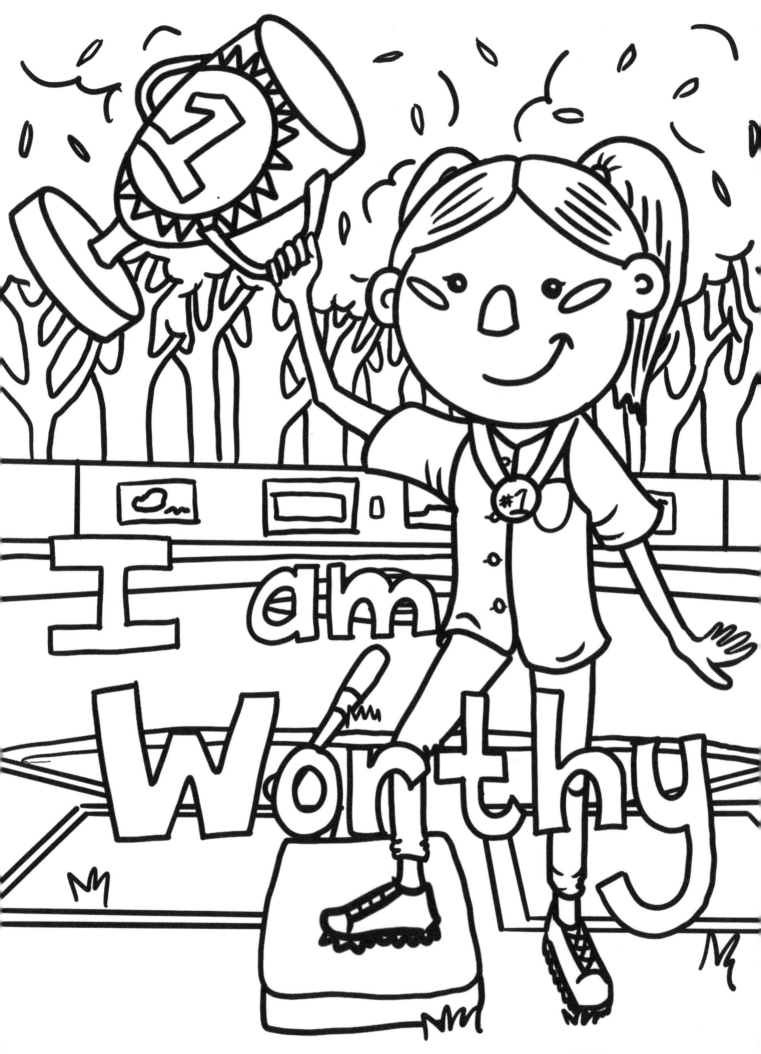

I know I am worthy because...

1._____

_____.

2._____

_____.

3._____

_____.

I am the perfect creation of what God intended when he created me... I am Amazing!

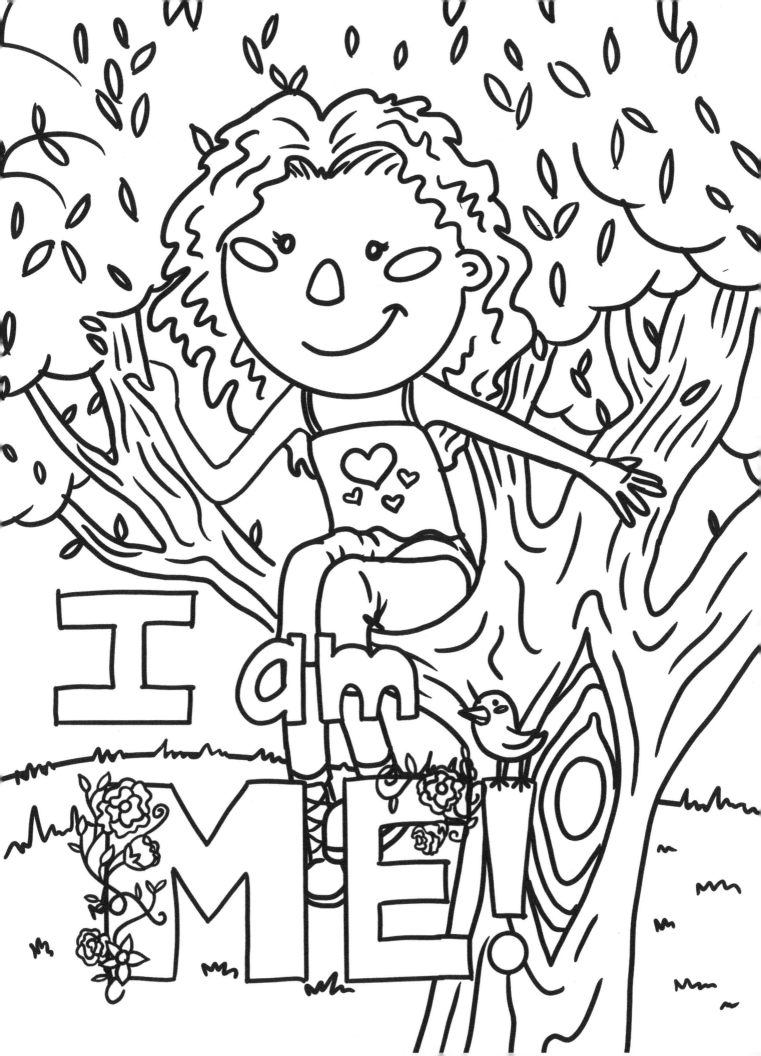

CPSIA information can be obtained
at www.ICGtesting.com
Printed in the USA
JSHW010922061120
9346JS00002B/8